Sarah's Tea Time

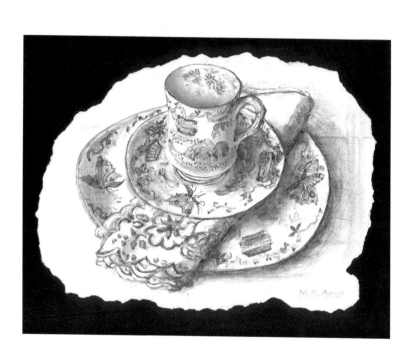

Sarah's Tea Time

*Delicious things to eat
with Afternoon Tea*

SARAH AMOS

Victoria · Vancouver · Calgary

for Robert

TouchWood Editions
108 – 17665 66 A Avenue
Surrey, BC V3S 2A7
www.touchwoodeditions.com

TouchWood Editions
PO Box 468
Custer, WA
98240-0468

LIBRARY AND ARCHIVES CANADA
CATALOGUING IN PUBLICATION
Amos, Sarah
Sarah's Tea Time / Sarah Amos.
ISBN 978-1-894898-76-8
1. Afternoon teas. 2. Cookery. 3. Tea cakes. I. Title.
TX736.A46 2008 641.5'36 C2008-903087-7

Proofread by Sarah Weber
Book design by Frances Hunter
Cover Painting: Aunt Muriel's Aynsley tea service
on a tablecloth worked by Sarah's mother, Megan Bone.
Sarah Amos, oil on canvas, 2008.

Printed in Canada

British Columbia Arts Council

Canada Council for the Arts

Conseil des Arts du Canada

TouchWood Editions acknowledges the financial support for its
publishing program from the Government of Canada through the Book
Publishing Industry Development Program (BPIDP), Canada Council for the
Arts, and the province of British Columbia through the British Columbia
Arts Council and the Book Publishing Tax Credit.

M. Sarah Amos

Contents

Tea Time

EVERYONE HAS A SPECIAL KIND of tea ceremony. This book looks back to the way tea was served at my family's houses in Britain.

At Aunt Mary's farmhouse, Leigh Court in Gloucestershire, tea time was a daily occurrence at 5:00 P.M. You could set your watch by it! Leigh Court was a dairy farm and everyone had been up and working since early morning. Breakfast was served at 8:00 A.M. and dinner was at 1:00 P.M. Both were robust meals. Tea was the last meal of the day.

There were at least six and often as many as ten people around the large oval dining table in the "breakfast room" (which was distinct from the more formal dining room). Entire loaves of white and whole-wheat bread were available, to be cut in the thickness of slice each person preferred. In addition, thinly sliced buttered bread was set out on a cake plate for the ladies. Men and children usually preferred thick slices, "doorsteps," which my uncle, the farmer, cut from the loaves. He handed them down the table on the end of a bread fork.

Jams and jellies made from home-grown fruit, Gentlemen's Relish and Marmite were available as well, and salted and unsalted butter. There were two or three kinds of sweets and squares, and at least one cake. This was often a simple sponge cake, split and filled with jam or icing. At other times we enjoyed a chocolate cake with a ganache icing. On special occasions a fruitcake was offered — a Simnel cake with marzipan at Easter and a rich fruit cake at Christmas.

The hostess presided over the teapot at one end of the table. The tea, in a silver pot, was made strong and she kept a pot of

boiling water at the ready to top up the pot or dilute the tea if it got too strong. At our family's tea time, if you asked for milk it went into the cup first.

My mother's teas were similar to my aunt's but on a smaller scale, since we were a smaller household. From a very early age I first played, then subsequently helped and later took over in the kitchen, making most of the cakes and cookies for my mother. Her old and battered cooking scales and weights are now on display in my kitchen but I rarely use them, because most recipes here use volumetric measures – cups and tablespoons.

The cakes and jams at home were always the finest. Fresh butter, cream and eggs ensured the best results. These days, at my house I use organic eggs, milk and flour for that good taste.

Of course, fashions change. Folks now aren't likely to want a meal with only bread and cakes. For a big tea party, I would include small fruits, such as grapes or berries, washed and drained. Also, we tend toward savouries such as some Stilton cheese, Comox Valley camembert and smoked salmon sandwiches, as most people I know go very easy on the cakes and cookies.

❈ How to Make a Pot of Tea ❈

THE IMPORTANT THING is to make sure the water is absolutely boiling and that the teapot is warmed before making the tea.

Bring a kettle of water to a boil. Pour half a cup or so of the hot water into the teapot, put the lid on the teapot (use a cosy if you have one) and allow it to sit for a minute or until the teapot feels hot. Bring the kettle back to a full boil, discard the warming water from the teapot, add the tea and pour boiling water on it. Let it stand for a few minutes.

How much tea to use? How many minutes to steep the tea?

This is all personal preference. In my house we use one teabag for four cups of water and steep it for four minutes, then remove the teabag. This is quite weak tea, but it is how we like it. It's more convenient for me to use a teabag, and then remove it from the pot, than to use loose tea.

If I am using loose tea, after the tea is steeped I usually pour the tea off the leaves into a second warmed teapot so that the tea doesn't go on steeping until it is too strong to drink.

To keep the tea hot you can use a cosy, or you can make the tea in a Thermos (glass-lined, not plastic). However many teabags you want to use, and however long you want to steep the tea, there comes the moment when it is just as you like it. And that is the way you should make your tea!

Pinwheel Sandwiches

·······································

Easy to make ahead of time, smoked salmon
pinwheel sandwiches are a classic. Some bakeries will slice
the bread lengthwise, which cuts down prep time.

½ cup butter at room
temperature
1 teaspoon grated
lemon peel
chives or dill, finely chopped
1 loaf whole-wheat bread
250 grams (8 ounces)
smoked salmon
black pepper
lettuce leaves

Mash butter with grated lemon
peel and chives or dill.

1. Slice the loaf lengthwise
to make 8 or 9 slices and trim
off crusts.

2. Working with short ends of
slices toward you, spread each
slice of bread with the butter.

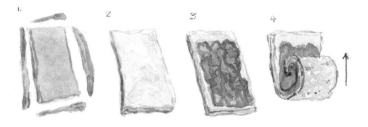

3. Lay smoked salmon on bread, leaving about ½ inch uncovered at the far end. This will be used to seal the sandwich after rolling up. Lightly sprinkle with freshly ground black pepper.

4. Roll up each sandwich, pressing the buttered end of the bread into the roll to seal. Wrap in plastic wrap. Refrigerate for an hour or more to help set the sandwich in its rolled-up shape.

To serve, cut the rolls into slices and arrange them on a platter garnished with lettuce leaves.

Variations

Substitute a good ham, thinly sliced, for the smoked salmon. Substitute mashed avocado for butter in either the salmon or ham sandwiches. Roll sandwiches around a lightly steamed asparagus spear.

Buttermilk Scones

Scones are very simple and rather plain. Nevertheless, presenting a batch of warm scones at the tea table turns the tea time into a special event. Served in a wicker basket lined with a linen cloth, they are best eaten with butter and jam.

1⅞ cups flour
1 tablespoon sugar
1 teaspoon baking powder
½ teaspoon baking soda
¼ teaspoon salt
¼ cup cold butter
1 egg
1 cup buttermilk,
 approximately

Preheat the oven to 400 degrees F.

Lightly grease a baking sheet.

In a large bowl, mix flour, sugar, baking powder, baking soda and salt. Cut in the butter; i.e., use two knives and chop the butter into small lumps, the largest about the size of a pea. Alternatively, rub in the butter with your fingertips as you would for pastry, or use a food processor, being careful not to overprocess.

Beat the egg lightly, stir it into the buttermilk and add to the dry ingredients. Mix lightly to a loose dough. If you are using a food processor, just a very few pulses of the machine will be all you need.

Turn the dough onto a floured surface and knead it lightly, folding the dough 2 or 3 times until firm enough to pat out into a circle about ½ inch thick. Cut into wedges and carefully lift onto the baking sheet.

Bake for 12 to 14 minutes or until coloured lightly golden on top. Remove from baking sheet to (for instance) a basket lined with a linen napkin or tea towel, and serve as soon as possible.

Variation

If you don't have buttermilk, use regular milk, but omit the baking soda and increase the baking powder to 2 teaspoons.

Shortbread

Butter is the only fat used in this traditional recipe.

1 cup butter
2/3 cup sugar
2 1/2 cups flour
sugar to sprinkle

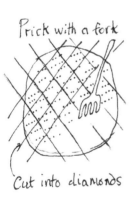

Prick with a fork

Cut into diamonds

Preheat the oven to 350 degrees F.

Cream the butter. Add the sugar and beat well. Stir in the flour and mix until blended. Press the crumbly mixture together to form a loose ball of dough. (Very easy to do in a food processor.)

Roll out the dough on a floured surface until about 1/2 inch thick. Prick all over with a fork, and lightly sprinkle with sugar. Cut into diamond shapes (or use cookie cutters).

Bake for about 10 minutes or until the edges begin to turn a very light golden colour. Watch carefully to avoid burning. Cool on a wire rack.

Lemon Hazelnut Bars

We traditionally serve these at Christmas parties and everyone likes them — especially me. They are just about irresistible, in the same way the Pecan Rum Squares are.

Base
2 cups flour
1/3 cup sugar
1/4 teaspoon salt
3/4 cup butter
3/4 cup hazelnuts, whole

Topping
4 eggs
1 1/2 cups sugar
1 or 2 tablespoons grated lemon peel
1/2 cup lemon juice
1 tablespoon flour
1 teaspoon baking powder

Preheat the oven to 350 degrees F.

Base: In food processor, combine flour, sugar, salt and butter, and pulse to chop butter into dry ingredients. Add the hazelnuts and pulse until they are chopped finely into the mixture. Tip this mixture into a 9- by 13-inch cake pan and press down lightly. Bake for 15 minutes. While the base is baking, prepare the topping.

Topping: In food processor, combine lemon peel, lemon juice, eggs, sugar, flour and baking powder. Mix well.

M. S. Amos

Pour this topping onto the partially baked base and return the bars to the oven for about 25 minutes, or until the topping is golden.

Remove from oven, cool in the baking pan and cut into bars when cold.

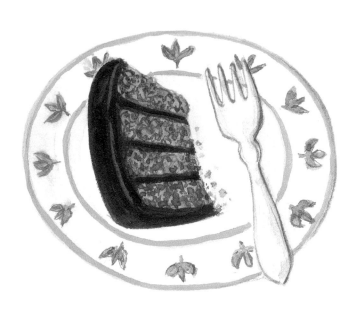

Chocolate Ganache Cake

. .

*I love dark chocolate. My chocolate cake is made
with ganache spread between the layers. You may serve the
cake fresh but we prefer to "age" it in the refrigerator or freezer
for a few weeks — or more! This seems to integrate the flavours.
This cake is so rich that it's nice with some fruit — raspberries
or cantaloupe — and a scoop of vanilla ice cream on
the side. Mind you, it's great on its own, too.*

*This is not a cake you can make in a hurry.
Set the chocolate to melt 10 minutes before you start to
make the cake, and later let the cake get completely cold before
proceeding to make the ganache. I usually make the cake
one day, wrap and refrigerate it, and then make the
ganache and assemble the layers the next day.*

Chocolate Ganache Cake

Cake

1 1/2 ounces unsweetened
 chocolate
2/3 cup butter
1 cup sugar
3 eggs
2 cups flour
2 teaspoons baking powder
pinch of salt (optional)
2/3 cup milk

Ganache

11 ounces semi-sweet
 chocolate
1 cup whipping cream
2 tablespoons butter
1 tablespoon vanilla
 (optional)

Melt the chocolate in a small covered dish over a bowl of very hot water (10 minutes).

Prepare two 7- or 8-inch light-coloured cake pans (*see* Notes about Baking, page 36).

Preheat the oven to 350 degrees F.

Cake: Cream butter and sugar, add eggs, beat well. Stir in the melted chocolate. Sift the flour, baking powder and salt, and gently fold this into the creamed mixture alternately with the milk. Divide the batter into the cake pans and bake for about 20 to 25 minutes or until a knife inserted in the middle of the cake comes out clean. Remove cakes from pans, cool on a wire rack. Let the cake sit for a few minutes, then tap or shake gently to loosen it from the

sides of the pan. Turn the cake out onto a wire cooling rack.

Ganache: Break the chocolate into small pieces and put them in a bowl. Over medium heat bring the cream and butter to a boil and immediately pour over the chocolate pieces. Add vanilla. Cover (e.g., with clean cloth) to keep the heat in. Let stand for ten minutes, then stir until smooth.

Assemble Cake: Cut the cakes in half horizontally to make four layers. Spread ganache between the layers and pour the rest over the cake, smoothing it out over the top and down the sides with a spatula. Refrigerate.

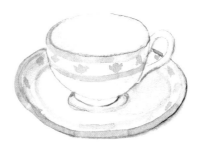

Mom held the
bowl while I
stirred

Marjorie's Oat Cookies

Robert's mother gave me this recipe. My mother-in-law made them with raisins but we prefer sunflower seeds or dried cranberries. Tastes change. This recipe makes about 40 cookies.

1 cup butter at room temperature

3/4 cup brown sugar (lightly packed)

1/2 cup white sugar

1 egg

1/2 teaspoon vanilla or rum

1 1/2 cups flour (whole wheat is okay)

1 teaspoon baking soda

1/2 teaspoon salt

2 cups large flake rolled oats

1/2 cup sunflower seeds or dried cranberries, or a combination of them

1/4 cup or so fine dried coconut flakes (optional)

Preheat the oven to 350 degrees F.

In a medium-size mixing bowl, cream butter and sugars. Add egg and vanilla or rum, and beat well. Mix in flour, baking soda salt. Stir in oats, then seeds, cranberries and coconut. If you are using a food processor, do this last step by hand, to keep the oats, seeds and cranberries whole. Make balls of dough about the size of walnuts, arrange them on a cookie sheet and slightly flatten them with a fork that has been dipped in cold water.

Bake for about 12 to 14 minutes. Cool cookies on a wire rack.

Chocolate Chip Cookies

Nothing is more popular than chocolate chip cookies. They were one of the first things my children wanted to learn how to bake. Robert insists that the chocolate-to-cookie-dough ratio be kept very modest, but you can adjust the chip count up or down to your own taste. This recipe makes about 40 cookies. Make it in a food processor if you have one.

1 cup butter
3/4 cup brown sugar, lightly packed
3/4 cup white sugar
2 eggs
1 teaspoon vanilla or rum
2 cups plus 2 tablespoons flour
1 teaspoon baking soda
1 teaspoon salt
2/3 cup chocolate chips

Preheat the oven to 350 degrees F.

Cream butter and sugars. Beat in eggs and vanilla or rum. Add flour, baking soda, salt and chocolate chips. Stir well. Drop by large teaspoons onto ungreased cookie sheets and bake for 12 minutes or until golden. Remove to wire racks to cool.

Chocolate Chip
Cookies

Cream together:
- 1 cup butter
- 3/4 cup brown sugar
- 3/4 cup white sugar

Beat in:
- 2 eggs
- 1 teaspoon VANILLA ESSENCE or rum

Stir in:

- 2 cups flour
- 1 teaspoon baking soda
- 1/4 teaspoon salt
- 2/3 cup chocolate chips
- 1/4 cup nuts or seeds (optional)

Stir well.

Set oven to 350°F. or 180°C.
Put small spoonfulls of mixture on
baking sheets. Bake 10 to 12 minutes
until golden.

Emily's Ginger Cookies

From time to time, my daughter Emily makes these cookies for a friend or associate, to say thank you for a favour. Emily says it is much more personal than a thank-you card. When the aroma of these baking cookies fills the house, the whole family arrives in the kitchen, hoping to be given a few cookies before the rest are arranged in a pretty basket to be given away.

3/4 cup butter
7/8 cup sugar
1 egg
1/4 cup plus 1 tablespoon molasses
2 cups flour
1 tablespoon ground ginger
1 teaspoon cinnamon
2 teaspoons baking soda
1/2 teaspoon salt
sugar to sprinkle

Preheat over to 350 degrees F.

In a large bowl, cream butter and sugar. Add egg and molasses and beat well. Stir in flour, spices, baking soda and salt. Make dough into 1-inch balls and roll them in the sugar to coat. Place on ungreased cookie sheets. Bake for 10 to 12 minutes.

If you overbake these cookies they will get quite hard, so be careful of the time. Remove cookies to a wire rack to cool.

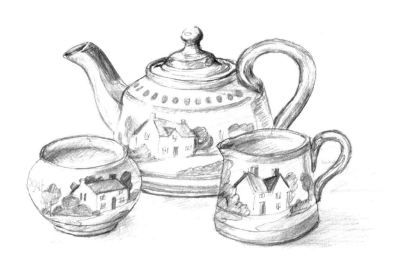

Berry Cake Dessert

This is a very "ordinary" cake, just the thing for a family tea. It is delicious with ice cream or yogurt while still hot from the oven. Use either fresh or frozen berries. Made with frozen berries, it's an economical wintertime treat. Substitute other berries or chunks of fruit for variations. I wouldn't serve this at an elegant tea party but it is just too good to leave out of this book.

2 3/4 cups flour
1 cup sugar
2 teaspoons baking powder
1/2 teaspoon baking soda
1 1/2 to 2 cups of berries, fresh or frozen (if strawberries are very large, cut them up)
2 eggs
1/2 cup canola or safflower oil
1 cup plain yogurt (or buttermilk)
3/4 cup milk (approximately)

Preheat the oven to 350 degrees F.

Butter and flour an 8- by 12-inch pan (*see* Notes about Baking).

In a large bowl, mix flour, sugar, baking powder and baking soda. Add berries. Mix gently to separate berries and coat them with the dry mixture.

In a smaller bowl, mix eggs, oil, yogurt and about half of the milk. Gently blend this into the berry mixture. As you mix, if the batter

Extra Berries?

Make a small pot of refrigerator berry jam.

2 cups berries, fresh or frozen

1 cup sugar

Chop berries, mix with sugar, bring to a fast boil in a medium-size saucepan, then cool slightly and put in a clean, warm jam jar. Very good served with scones. As this jam has less sugar than regular jam, it will need to be refrigerated, but it won't last long!

feels at all stiff, add a little extra milk — the batter should be quite soft. Tip batter into prepared pan.

Bake 30 to 40 minutes, adding an extra 10 minutes if the berries were frozen, or until a knife inserted in the middle of the cake comes out clean.

※ Butter versus Other Fats for Baking ※

BUTTER HAS BEEN AROUND for a long time. I think it is safer for my health than margarine or that hydrogenated vegetable-oil product that has a shelf life of forever. Butter's flavour is the best for baked goods, and for tea-time specialties I wouldn't use anything else. But butter is a saturated fat, so don't have baked goods too often: special occasions only. In small quantities once in a while, they shouldn't be a problem.

Pecan Rum Squares

..

This is the recipe I warned you about earlier. Irresistible.

Base

3/4 cup butter

1 cup sugar

1 1/2 teaspoons rum
 (or vanilla)

1 egg yolk

1 7/8 cups flour

Topping

1 egg white

1 cup chopped pecans

Preheat the oven to 350 degrees F.

Base: In food processor, cream butter, sugar, rum and egg yolk. Add flour and pulse to mix. This is a crumbly mixture.

Press mixture firmly into a shallow 9- by 13-inch pan. Do this with your bare hands, and continue pressing until the surface is greasy shiny smooth. This step is important; be careful to press the mixture in this way right to the corners so that when you spread the topping over the base, the topping will stick to it, rather than the base lifting off into the topping.

Topping: Beat the egg white with a fork in a small bowl until foamy, then spread it over the surface with your bare hands or a brush. Sprinkle the chopped pecans over the top and press them lightly into the surface with a rolling pin.

Bake for about 14 or 15 minutes or until the edges are turning golden. Turn onto a rack to cool (*see* below).

To avoid having the nuts knocked off on the rack, use two racks and a tea towel as follows. First, gently run a knife around the edge of the squares to loosen them; then cover the squares with a clean tea towel and place a rack on top. Invert and remove baking pan. Place a second rack over the inverted squares, and turn over again. Remove the first rack and tea towel and allow the squares to cool. When they are cool, slide them onto a board and cut them.

Almond Cake

*This recipe is derived from one in a wartime cookbook
of my mother's. Because of wartime shortages there was
not much dried fruit available — only a few raisins and
some crushed almonds. Over the years I have modified it into
something considerably richer, and it is a family favourite.
I offer it here — with the raisins eliminated and a more
generous ground almond component — for the first time.
A thin slice goes a long way.*

1 cup butter
1 cup sugar
3 extra-large eggs
¾ cup ground almonds
2 cups flour
1 teaspoon baking powder
½ teaspoon salt

Preheat the oven to 250 degrees F.

Prepare a light-coloured metal baking pan. I use a loaf pan, but you can use a round pan. Lightly grease the pan, then sprinkle flour over it. Tap the pan hard to shake loose excess flour and discard it.

Cream the butter and sugar, in a food processor if you have one.

Add the eggs one at a time, beating well after each addition. Stir in the ground almonds.

Stir in the flour, baking powder and salt. If you are using a food processor, pulse until mixed, about 7 to 10 pulses. If your processor is not powerful enough to do this step, tip the mixture into a bowl and mix it by hand.

Turn mixture into prepared baking pan and bake for about 2 hours and 20 minutes. To test if cooked, insert a knife into the centre of the cake. If the knife comes out clean, the cake is done. Cool on a wire rack.

Sarah's Christmas Cake

This is a very rich cake but also deliciously moist,
thanks to the unusual addition of the pineapple with its juice.

1/2 pound blanched almonds
1/2 to 3/4 pound pecans
1 to 1 1/2 pounds mixed peel
1/4 to 1/2 pound dried
 cranberries
1 pound raisins
2 tablespoons rum
 or brandy
1 1/2 cups flour
1 1/2 teaspoons baking
 powder
1 cup butter
1 cup sugar
1 teaspoon vanilla or rum
 or brandy
1 teaspoon lemon juice
4 egg yolks
1 1/2 cups flour
1 can (540 ml) crushed
 pineapple with juice

In a large bowl, combine the nuts, fruit and rum or brandy. Leave the mixture to soak for an hour or two.

When you are ready to continue, prepare the cake pans. This recipe will fill 2 regular bread pans plus 2 miniature loaf pans. Butter the pans, then line them with brown paper cut to fit, allowing the paper to stand up an inch above the sides of the pans. Generously butter the paper, which will stick nicely to the buttered pan. Cut extra pieces of paper to lay over the tops.

Preheat the oven to 300 degrees F.

Add the first measure of flour and baking powder to the fruit-and-nut mixture and mix well.

In another bowl (or in a food processor), cream the butter and sugar and add the vanilla, rum or brandy, lemon juice and egg yolks. Stir in the second measure of flour and then mix in the can of pineapple.

Add the creamed mixture to the fruit-and-nut mixture and blend well. Put into prepared pans. Cover pans with the pre-cut paper for half of the cooking time.

Bake for 2 to 3 hours, or until a knife inserted in the centre comes out clean.

⁂ Notes about Baking ⁂

MEASURING CUPS

Quite a few years ago, measures changed from imperial to metric.
Now our measuring cups are slightly bigger than they used to be —
500 mL, instead of 454 mL (which is half a pint). However, butter
is still sold by the pound, and we usually equate half a pound
of butter with 1 cup (as marked on the butter wrapper). Those
cups are actually smaller than the ones we use for measuring
our flour and sugar. When I list the ingredients in my recipes,
for simplicity's sake I always indicate "1 cup flour," as do most

recipes. But when I actually measure out my flour and sugar for baking, I always use a rather scantily filled cup to accommodate this inconsistency in measuring cup sizes. I recommend doing that when using the recipes in this book.

Food Processors and Mixing by Hand

I often use a food processor to mix cakes and cookies, being careful not to overprocess. It's a fast way to mix and I can use butter straight from the fridge. If I decide to mix by hand (which is more fun if making cookies with a beginning cook), I make sure my butter is at room temperature before starting. Several hours before it will be needed, put the butter in a bowl, cut it into large pieces, cover and allow it to sit for a few hours to bring it to room temperature.

Cake Pans and Cookie Sheets

For cakes and cookies I use light-coloured, shiny cake pans and cookie sheets, because then the sides and bottoms of my baked goods don't burn. If you use dark-coloured baking ware, then probably your baking won't turn out perfectly: the bottoms will

brown too much before the tops are cooked. Dark pans are good for breads or items on which you want to have a good crust.

Prepping Cake Pans and Cookie Sheets

Cake pans should be greased and then coated with a light layer of flour. To coat with flour, put a tablespoon of flour in the greased pan and shake it gently till the flour coats the inside of the pan. Tap the pan sharply to loosen excess flour and tip it out.

Cookie sheets can be left ungreased for cookies with a high fat content, e.g., Marjorie's Oat Cookies and Chocolate Chip Cookies, but for plainer recipes, such as Buttermilk Scones, the cookie sheets should be lightly greased.

Cooling Baked Goods

Cakes: Let the cake sit for a few minutes, then tap or shake gently to loosen it from the sides of the pan. If necessary, you can gently loosen the sides of the cake from the pan with a spatula or knife. Turn cake out onto a wire cooling rack. **Cookies**: Lift hot cookies from the baking sheet with a metal spatula and place on a wire rack. Wipe the hot cookie sheet right away with a damp cloth to clean it.

Some baked goods (e.g., the Lemon Hazelnut Bars) have to cool down completely before you can cut them and remove them from the pan. Others (e.g., the Pecan Rum Squares) need to be removed from the pan and cooled right side up before being cut, and I have included directions in that recipe.

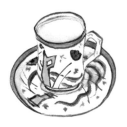

ACKNOWLEDGMENTS

In 2005 our friend Trolley Bus presented his World Tea Party at the Art Gallery of Greater Victoria. In preparation for this, I presented a tea party for 12 friends at my home, which was videotaped for the World Tea Party archives. This little book commemorates that event.

Many people have had a hand in the creation of this book and I would like to thank them all. In particular, thanks go to my husband, Robert, who organized my material into this book, and to my friends, who encouraged me to bring my recipes out into the world for other people to enjoy. Among many others I thank Ani, Anita and Joan's sister, Lynn. I am grateful to Kathy for teaching Emily to make the ginger cookies. And to my publishers, TouchWood Editions — this book is a team effort — many thanks.